staking LAND claims

WPG Editions

Edited by
Patricia Deadman and Paul Seesequasis

Banff Centre Press
Banff, Alberta

T

Canadian Cataloguing in Publication Date

Main entry under title:

Staking land claims

Catalogue of an exhibition held at the Walter Phillips Gallery, Feb. 14–Mar. 31, 1997.
Includes index.
ISBN 0-920159-59-1

1. Indian art—Canada—Exhibitions. 2. Art, Modern—20th century—Canada—Exhibitions. 3. Art, Canadian—Exhibitions. I. Deadman, Patricia, 1961– II. Seesequasis, Paul. III. Walter Phillips Gallery.
N6549.5.A54S72 1999 704'.0397071'0904 C98-911178-4

Edited by Patricia Deadman and Paul Seesequasis
Designed by Ann Hibberd/Mixed Media Creative Communications Inc.
Printed and bound in Canada by Transcontinental Printing

The Banff Centre Press gratefully acknowledges the support of the Canada Council for the Arts for our publishing program.

From an exhibition at the Walter Phillips Gallery, in partnership with the Aboriginal Arts Program at The Banff Centre for the Arts

Banff Centre Press
The Banff Centre for the Arts
Box 1020-50
Banff, AB T0L 0C0
http://www.banffcentre.ab.ca/Writing/Press/index.html

The Banff Centre
for the Arts

CONTENTS

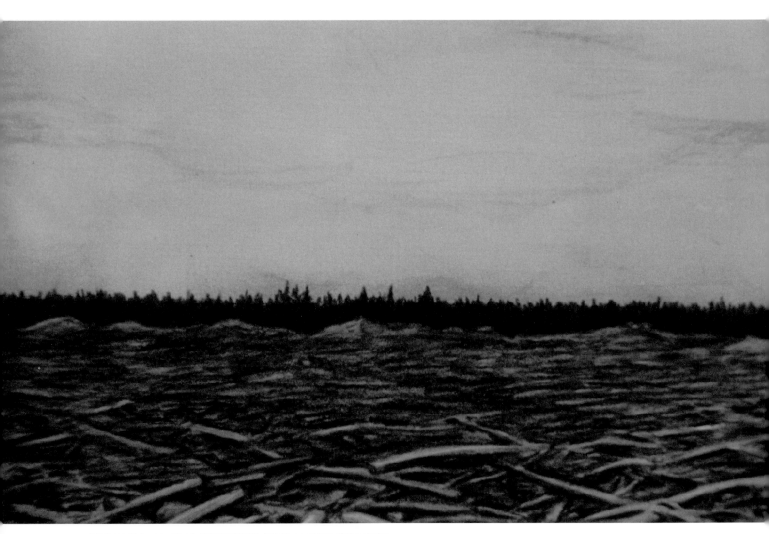

Michael Belmore, *Cord,* 1997 (detail), Photo courtesy of the artist

FOREWORD

In October 1995, I was first invited to participate in a meeting of the Aboriginal Film and Video Art Alliance council and The Banff Centre for the Arts. As the newly appointed Curator of the Walter Phillips Gallery, I came to that meeting with a great deal of anticipation and enthusiasm over the role the Gallery could play in the future of the Aboriginal Arts Program at The Banff Centre. At that meeting, on behalf of the Walter Phillips Gallery, the former Director, Daina Augaitis, and I made a commitment to fully support one exhibition per year, to be determined by the Aboriginal Arts Program.

Over the course of the next year, I worked with Marrie Mumford, Director of the Aboriginal Arts Program at The Banff Centre for the Arts. We wanted to articulate what our shared goals and hopes for the first and subsequent collaborative exhibition projects would be. Recognizing that the Gallery was committed equally to investigations of curatorial practice and to the production and presentation of visual art, and that the Aboriginal Film and Video Art Alliance council had identified curating as a valued resource for Aboriginal communities, we found a focus. This was to maintain the processes of self-government within the arts while also highlighting the development of professional curatorial practice within First Nations communities.

In the spring of 1996, we distributed a Canada-wide call for curatorial proposals and convened a jury to review the overwhelming number of interesting applications and ideas that came to the table. It was a long and difficult process. I would like to express our thanks to that first panel of jurists for their invaluable contributions to this exhibition project, and to Morgan Wood, Curatorial Associate, who oversaw the call and jury administration.

The proposal for Staking LAND Claims, curated by Patricia Deadman, was remarkable for the way it incorporated both traditional values and contemporary issues, relating a centuries-old connection with the land to current environmental concerns. While looking back on histories of colonization and subjugation, the artists— Mary Anne Barkhouse, Michael Belmore, Kelly Greene, and Anne Walk—critically addressed contemporary struggles of Aboriginal communities to retain ancestral lands. The concern of these artists bridges all cultures and asks us to stake our claim to a shared responsibility for the land and its ecology.

Following the opening of the exhibition, Michael Belmore and Patricia Deadman, accompanied by Heather Henry and MJ Thompson, toured across southern Alberta, bringing ideas and images from the exhibition to regional Aboriginal schools and reserve communities. I am deeply grateful to the Canada Council for the Arts for supporting this project, and to the staff of the Walter Phillips Gallery for making both the exhibition and community outreach project such

a success: particularly MJ Thompson, Public Program Coordinator; Mimmo Maiolo, Preparator; Debra Reeve, Assistant Preparator; and Heather Klassen, Administrative Coordinator/Registrar. It is always a great pleasure to work with such a dedicated and talented group of people. I would also like to thank the staff of the Aboriginal Arts Program: Heather Henry, Deborah Prince, and Rebecca Ward for their hard work and support.

Over the past few years, in this and many other collaborative projects, Marrie Mumford and I have shared a wealth of experiences and

ideas. I am very grateful to her for her spirit, guidance, and words of wisdom. Finally, it was my great honour to be able to work with Patricia Deadman, Mary Anne Barkhouse, Michael Belmore, Kelly Greene, and Anne Walk over the course of this exhibition project. I am grateful to each of them for their creativity, generosity, and ongoing friendship.

Catherine Crowston, Senior Curator
Edmonton Art Gallery

INTRODUCTION

MARRIE MUMFORD

"A human being who has a vision is not able to use the power of it until after they performed this vision on earth for people to see." — *Black Elk, Oglala Sioux*

"To govern ourselves means to govern our stories and our ways of telling stories.... To re-imagine and reclaim our ground in the intimate, small, everyday things of life and community is to become self-governing."

— *Marjorie Beaucage, Métis, Aboriginal Film and Video Art Alliance*

Staking LAND Claims, an exhibition curated by Patricia Deadman, opened at the Walter Phillips Gallery in February 1997. It was to be the first in a series of annual exhibitions by Aboriginal curators at The Banff Centre for the Arts. The vision for this series began in August 1993, at a national gathering of Aboriginal artists. There, a cultural partnership between the Aboriginal Film and Video Art Alliance and The Banff Centre for the Arts was undertaken. The Aboriginal Arts Program is the result of this partnership.

Artists from across the land gathered at Sleeping Buffalo Mountain to explore traditional storytelling and its relationship to the practice of Aboriginal self-governance in the arts. The purpose of the gathering was to explore the creative possibilities inherent in creating a space for Aboriginal artists to work within a cultural context at The Banff Centre. The desire to create a space where culture can be lived, a homeland where the spirit can dwell, a gathering place to create forms of expression based upon Aboriginal values, was profound.

Traditions and beliefs, and the bridging of traditional principles and contemporary expressions from a diversity of nations, stories, and experiences of Aboriginal peoples were at the heart of the vision to create a place—a place where artists can reclaim what is lost, to create anew, and to determine their own forms of creation. That is the principle behind the partnership.

In the fall of 1995, having recently arrived at The Banff Centre as the Director of the Aboriginal Arts Program, I met with Catherine Crowston, then newly appointed Curator of the Walter Phillips

Gallery. From that moment and into 1996, we worked together and laid the groundwork for the first collaborative exhibition project between the Aboriginal Arts Program and the Walter Phillips Gallery. There were many who contributed to this process from the vision to the realization. To all, I am deeply grateful.

In 1997, Staking LAND Claims, the first exhibition, opened the third annual Aboriginal Winter Village at The Banff Centre. I could feel the excitement in the air. The artists—Mary Anne Barkhouse, Michael Belmore, Kelly Greene, and Anne Walk—with curator Patricia Deadman, transformed the Walter Phillips Gallery. They created a powerful installation with poignant, gentle, challenging, and humorous images. Their work guided us with a multiplicity of voices through profound Earth journeys combining history, memory, and imagination.

As I listened to the artists' stories of the journeys that had brought them to this point of creation, I felt many ancestral voices converging on the moment. Their voices bonded us viewers of this work as a community to the land, where we experienced the heartbeat of the earth and could identify the earth within ourselves. Reconnecting across many species and cultures, reclaiming journeys in the footsteps of ancestors—in these moments I am struck by the necessity and the shared urgency of staking *our* claim to the LAND, and the responsibility of claiming it for generations yet to come.

Remembering the desire of one collective preparing the way for another, I am aware that the dream of one generation shapes the visions for the next, generating this energy throughout the universe. I pay tribute to those who dreamed, seven generations ago, that we would return to these sacred mountains, reclaim what has been left for us along the way, creating the stories of this time for future generations.

Chi Meegwetch to all who brought this partnership to fruition, creating a place for Aboriginal artists to find a community here. *Hi hi* to Catherine Crowston—colleague, friend, and Curator for the Walter Phillips Gallery—and her staff, who, when presented with the priority needs for Aboriginal curatorial practice of self-governance, not only embraced the concept but created a space for us in the gallery and in the budget.

Hi hi to Patricia Deadman and the artists who created Staking LAND Claims. The journeys they have taken and the vision, passions, and commitment they have conveyed to this exhibition are powerful.

Also *hi hi* to Carol Phillips, Director of The Banff Centre for the Arts, who has been an unswerving supporter of Aboriginal artists and the practice of self-governance in the arts—always affirming our right to tell our stories in our own way.

And a special thanks to all who envisioned this project and worked to make this book a reality. *Meegwetch* to Don Stein, Director of Writing and Publishing at The Banff Centre for the Arts, who has supported the Aboriginal Arts Program from the beginning; and to Lori Burwash and Lauri Seidlitz, editors of the Banff Centre Press; and to Paul Seesequasis, editor. Thank you all for your patience, persistence, and encouragement.

INTERIOR AND EXTERIOR LANDSCAPES
LYNN HILL

A myriad of cultural, social, political, and religious ideologies have shaped our relationship to the land. They have erected boundaries, begun wars, and caused separation. The only unifying factor has been the importance of the land to our identity and existence. The land is a memory bank of information. It holds the key that will determine our extinction or our survival. Archaeologists strive to uncover the mysteries of past civilizations while huge corporations scurry to "develop" the last of the earth's natural resources.

For First Nations people, the land was not merely a thing to be owned and consumed—it was an integral part of their lives. Within this world view, First Nations people respected the land as part of a much larger continuum. The land was central to their self-perception. Recently the relationship between First Nations people and the land has drawn media attention. The legacy of broken treaties and the ensuing reclamation of tribal lands and rights have become front-page news. Lubicon, Oka, and Ipperwash are only a few of the many words that have become embedded in our social and political vocabulary.

Staking LAND Claims is an exhibition of installation work by four First Nations artists. In their work, Mary Anne Barkhouse, Michael Belmore, Kelly Greene, and Anne Walk explore past and present relationships between the land and its dwellers. They address issues of cultural perception, tradition, memory, ecological fate, identity, and personal concerns. In an act of survival and self-definition, these artists use the power of visual language to create narratives that cite personal experiences and perspectives within a larger universal context.

Our truth, our words, and our reality are not those of our grandparents. We now exist in a landscape that is overwhelmed by Western consciousness. Within an urban context the notion of wildness is still self-evident.

Michael Belmore

Mary Anne Barkhouse

Mary Anne Barkhouse is a mixed-media artist who was born in Vancouver, British Columbia, and currently lives and works in Minden, Ontario. Animals, usually wild, are a frequent image in her work. By observing these animals in their natural—and sometimes controlled—environments, Barkhouse establishes a parallel between human and animal behaviour. She shows how human behaviour has often had an adverse effect on our social and physical world.

Wolves in the City, a suite of five Cyanotype and VanDyke-brown images on paper, places images of wolves within an urban, or human, environment. The wolf is a common image in her work. For Barkhouse, the wolf has come to represent fears that are deeply rooted in our collective psyche.[1] This fear of the wolf, the archetypal character in stories and legends from around the world, has been instilled in us from an early age. Seemingly innocent fairy tales, such as Little Red Riding Hood and The Three Little Pigs, teach us that wolves are evil. These perceptions are not dissimilar to the popular-culture stereotypes perpetuated for the longest time about First Nations people. *Stagecoach*, an early John Wayne film, is only one of a whole western genre that portrayed Indians as fearsome and pesky, keeping alive the attitude that "the only good Indian is a dead Indian."[2]

The urban, humanized sites that Barkhouse has chosen are places that large numbers of people visit or traverse on a daily basis: the highway, a friendship centre, the Parliament buildings, a public monument, and a movie theatre. The images of the wolves are printed in VanDyke brown against the blue Cyanotype of the public spaces. In doing this, Barkhouse creates a physical and psychological distinction between the two. In one image, two wolves wait patiently beside the road; above them a signpost warns travellers of "Night Danger."

Moose crossings can be dangerous for the traveller, especially at night, when visibility is limited. The sign, however, hints at another, more

Burnt into our collective psyche is the lurking fear of the wild canine, come to call for our children or our souls.

While the recent expansion of monsieur le coyote into surburban communities has been received rather less well

by the cats, it has been a welcome sign of nature's ability to provide a quick response to industrialized adversity.

Whether visiting a monument, waiting by the road or taking in some theatre, the universal "we" must extend to

things previously designated as varmint, i.e., Indians, wolves, Richardson's Ground Squirrel. As a surrogate for the

displaced, the wolf represents the possibility of reintegrating the "other" into the global arena.

Mary Anne Barkhouse

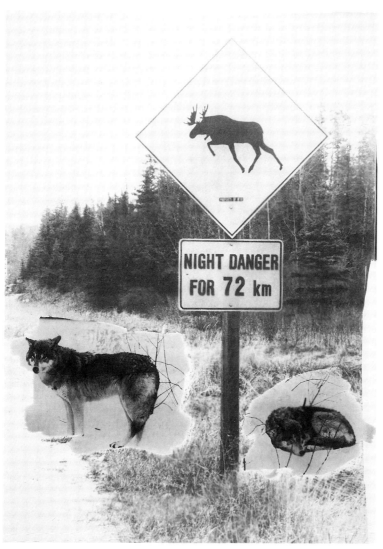

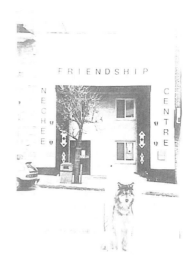

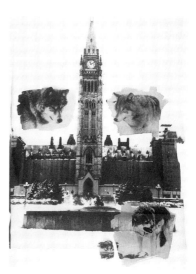

Mary Anne Barkhouse, *Wolves in the City*, 1997 (details), Photos courtesy of the artist

primal fear—that of the night, the dark, the unknown. In this image the wolves are not so much out of their environment as they are consciously absent. She returns them to what should be their natural environment, as if to remind us whose land these highways pass through.

By commenting on the displacement of wolves from their natural surroundings, Barkhouse is drawing a comparison to the forced removal and placement of First Nations people onto Crown lands or reserves. Making her point even more poignant is the fact that the models for this series are Rocky Mountain timber wolves, currently residing at the Haliburton Wolf Research Centre.[3]

In *Wolves in the City*, Barkhouse is asking us to question the universal "we" and to reconsider the inclusion of the "other," whether that be wolves or Indians. As our physical and socio-political landscapes change, so too does our self-perception and the universal "we." According to news reports, sightings of cougars, coyotes, and wolves within urban centres are becoming increasingly common. Such occurrences not only enhance public fears but may also incite a witch-hunt mentality. Where's John Wayne when you need him?

For the viewer, Barkhouse creates an awareness of the environment that "we" live in and reminds us that there are "other" inhabitants.

Michael Belmore

Michael Belmore was born in Thunder Bay, Ontario, and currently lives in Minden, Ontario. In his current installation, *Flock*, Belmore questions issues of identity and culture as they relate to place. The power of place can be a significant factor in establishing identity. Historically, First Nations people have been identified in terms of place: Woodland, Northwest Coast, Great Plains, etc. Ethnographers and anthropologists used these generalized, geographical regions to systematically categorize First Nations people. With the implementation of the Indian Act of 1876, First Nations people were relocated and consigned to lands known as reserves. In this manner, the Canadian government attempted to contain the "Indian problem."

Today, First Nations people are challenging both geographical generalizations surrounding identity and the restrictive policies of the reserve. As in Barkhouse's work, Belmore draws an analogy between human and animal reactions to a changing social and physical environment.

Flock is a mixed-media installation consisting of ten consecutive graphite drawings installed at equal heights and intervals along a wall. Each drawing depicts a raven; some are in mid-flight, others are resting on tree branches. The place is unknown. These ravens may be in an urban environment or in the wild, but one thing is certain: the placement of the raven does not alter the fact that it is still a raven. Belmore's comment, regarding First Nations people, is that location

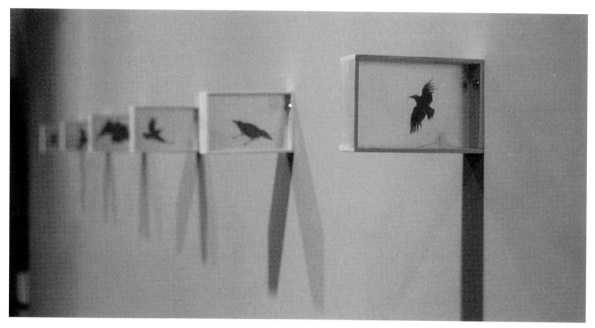

Michael Belmore, *Flock*, 1996 (installation view), Photo courtesy of Don Lee

does not limit identity. Place can contribute to identity but it does not necessarily define it.

"As free as a bird" is a phrase often used to describe one's desire for freedom. There is a liberating sense of movement in *Flock*. Belmore presents the ravens as separate and individual, yet part of a collective whole. This can be compared to the diverse identities among First Nations people. Many First Nations people have moved to urban centres, while others live in the countryside or on reserves. This does not change the fact that they are all First Nations people. Today, this sense of freedom is being exercised in the political arena as more First Nations establish their own definitions of self-determination.

Each graphite drawing has been numbered from one through ten. This numbering reminds one of the classic children's counting rhyme "Ten

Little Indians." In this seemingly innocent song, the Indian is viewed as an object, childlike and cute. Applying numbers to First Nations people also recalls the Indian Act and its policy of defining Indians as status or non-status. This arbitrary act not only defined who was Indian in the eyes of the government, it also served to divide nations and families.

In his installation *Cord*, Belmore comments on the often destructive relationship between man and the environment. Many of the great forests of the world have been destroyed through the gluttony of capital consumerism. *Cord* comprises three graphite drawings, one of which is mounted in a light box. This drawing depicts the end result of clear-cut logging. What was a lush, life-sustaining environment is now desolate devastation. Trees that once stood tall and provided shelter and life to

many living things no longer exist. In a clear-cut there is no concept of selective harvesting—everything is removed, nothing is left for the future.

Situated some distance from the first light box are the other two graphite drawings. These images have been double-hung and are installed so that they protrude from the wall, confronting the viewer like a signpost giving directions. The upper image presents us with a haunting depiction of an ideal forest. This drawing appears as an apparition—a ghostly reminder of what once was. In the lower image, a large piece of machinery is shown moving felled trees into a pile. It is the action of this drawing that brings the other two images together.

Belmore's title, *Cord,* refers to the unit in which cut wood for fuel is measured and stacked. By focusing on current logging practices and their ties to the land, he has linked these three drawings together like an umbilical cord. The natural cycle of life is destroyed when everything is consumed without concern for the future.

Mary Anne Barkhouse and Michael Belmore

In their first collaborative work, Barkhouse and Belmore explore the dual properties of their materials and how they relate to the formation of cultural traditions and identity. *Reservoir* is a mixed-media installation that includes six cast salt-and-polyester-resin objects. Each of the objects—a feather, bear claws, a braid of sweet grass, and three sections of a totem pole—is valued with esteem and power within First Nations cultures. In popular culture, on the other hand, these images have come to represent "icons of Indianess." This has led to misuse and a loss of cultural significance among the general public, making the objects nothing more than trivial kitsch.

Reservoir can be broken down into two separate suites of work. The feather, bear claws, and sweet grass rest upon individual steel and copper-topped stands. These stands are reminiscent of burial platforms. The brushed copper tops create a luminescent glow beneath the objects, as if silently offering them to the heavens. The solitude of this part of the installation instills a feeling of respect and honour for the objects. However, with time, the salt casts and copper tops create a chemical reaction and will eventually eat away at one another.

Barkhouse and Belmore have also cast three segments of a house post that was carved by Barkhouse's great-grandfather, Charlie James.[4] As Barkhouse comments on the life of the post, "[The house post] has gone from being a functional cultural object to film prop to an artifact in the

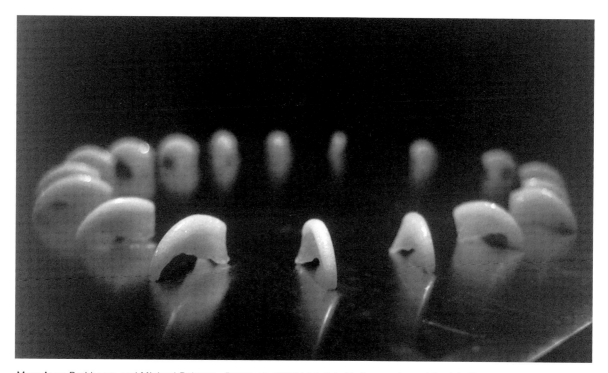

Mary Anne Barkhouse and Michael Belmore, *Reservoir,* 1997 (details), Photos courtesy of Patricia Deadman

collection of the Art, Historical and Scientific Association in Vancouver, to a tourist attraction in Stanley Park, to a plasticized version of a tourist object, to a salt object in an art gallery."[5] Only the figural elements of the post's imagery have been cast. They rest upon large cedar stands, a material from which the original posts were carved.

Visually, the salt casts of *Reservoir* stand as fragments of the past. The duality of salt, as both a sustaining and corrosive material, has also been explored. The virtues of salt are used as a metaphor for culture, preservation, and memory. Its usage has also created a tongue-in-cheek commentary on cultural identity. By casting "icons

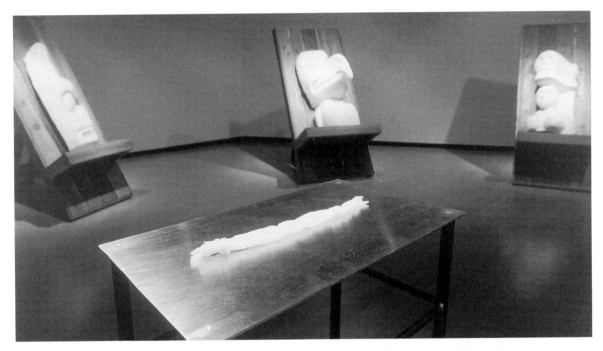

Mary Anne Barkhouse and Michael Belmore, *Reservoir,* 1997 (installation view), Photo courtesy of Michael Belmore

Reservoir is a reflection on the evolutionary process of culture. Traditional objects of ritual and everyday use common to our First Nations communities are re-created in cast salt forms, which reference both the original integrity of the iconography and history, and the formal properties of salt. With the unfolding of negotiations over land, culture, and government, a fine line is being drawn between that which communicates and that which commodifies.

Mary Anne Barkhouse and Michael Belmore

of Indianess" in salt, the artists play with the idea of salting: to give an object an artificial or false value. Here is the parity of the ideology found in the generic and inferior symbols employed by the tourist industry.

Reservoir contains and holds the ideologies of collective consciousness. Working together, Barkhouse and Belmore apply their knowledge of materials and images to address the trivialization and commercialization of First Nations' cultures as perceived by popular culture. They stake claim to objects that have been misappropriated and exploited; they reinvest these objects with new life and meaning.

Kelly Greene

Kelly Greene is a mixed-media installation artist who lives in London, Ontario. She refers to the environmental state of the land through her use of natural and man-made materials, reminding viewers of the struggle between nature and technology.

Earth as Human Nurturing Fate is an installation in which a sand-covered female figure appears to be raked over a series of railway ties that rest upon a sandy bed. Beneath the woman lies a sand-covered infant figure. The woman hangs helpless over the ties, her outstretched arms staked to an oxen yoke and her feet bound to the ties. The yoke is suspended from the ceiling by a cable attached to a steering wheel. This wheel is mounted on the facing wall.

Greene uses the female figure as a metaphor for Mother Earth. The oxen yoke attached to the woman refers not only to the working of the land, but also to the corruption of the land and its people by the Hudson's Bay Company—the yoke was once a symbol on the company's logo. The attachment of the yoke to the steering wheel alludes to the advancement and speed of technology in our lives. The woman has both her hands tied. She has little or no control over her situation. Her fate is bleak; she is unable to nurture the future represented by the small infant below her.

The sand-covered infant has a hemp umbilical cord attached to it. The cord has been cut and now the infant must survive on its own. Hemp also comprises the shorn hair of the woman. Cutting off one's hair can be viewed as an act of protest, punishment, disassociation with the past, or a fresh start. Greene offers little or no solution to the inevitable; instead, she assaults the viewer with her concern for our cultural and ecological fate.

In the two-part installation *Birthing Cave* and *The Breath of Earth*, Greene continues her examination of the relationship between nature and technology. Whereas *Earth as Human Nurturing Fate* notes our journey on a one-way street to doomsville, *Birthing Cave* and *The Breath of Earth* comment on the natural cycle of life and death as reaffirmed in the environment with which Greene is familiar. This installation requires viewer participation in order to be properly experienced (see guidelines on page 35).

Birthing Cave is a seven-foot, wooden, coffin-like structure that lies on the floor. For viewers to

experience the second part, *The Breath of Earth*, they must lie down in the coffin. The lid may be open or closed. At one end of the coffin is a opening of approximately ten centimetres. This measurement coincides with the ideal width of dilation for a natural birth to occur. *Birthing Cave* invokes the duality of life and death: one follows the other in a continuum.

It is through this opening that the second installation, *The Breath of Earth*, is properly seen. Looking through the hole, viewers are able to see into a seven-foot-tall, four-by-four-foot square space, shaped like a picket fence. Mounted on the facing wall of this enclosed space is a black-and-white photograph of the earth, centered in an industrial landscape. The massive globe is part of the waterworks filtration plant in Hamilton, Ontario, and is used as a holding tank. Painted to resemble the earth, the globe's only identified locale is Hamilton. This brightly coloured sphere is situated along the shore of Lake Ontario, in the city's east end, surrounded by steel mills and shipping yards. Visible from the highway, the globe has become a Hamilton landmark.

The picket fence is an idyllic urban device used to separate private from public lands. In Greene's work, the height of the picket fence creates a barrier that blocks the viewer from seeing what is on the other side. The fence is meant to contain, protect, and exclude elements that may alter the environment it encloses. It's as if Greene is creating a private and sacred space for the world.

A train figures prominently in both of Greene's installations. It is technology: forging across the Canadian landscape, connecting east with west, a primary component in the settling and urbanization of Canada. In *Earth as Human Nurturing Fate*, the railway ties signify time and location. The crucifixion of the female figure reveals Mother Earth as a martyr who must suffer for our technological advancements. The photo in *The Breath of Earth* depicts train tracks criss-crossing and encircling the globe as if to strangle it. Greene is drawing our attention to technological encroachments on the land that will eventually lead to society's demise.

Speed and time govern our lives, intensely gaining momentum as the millennium comes to a close. Humanity's current computerized, quickly obsolete, ever-changing lifestyle has the most detrimental effects on our Earth, our Mother, than in any time past. Racing through days, roads, lands, divided land, fenced-off, plotted, brings us closer to the fate we create. A crash may occur soon. If land took on human form, in what condition would she be? My optimism for the future is that all death brings rebirth.

Kelly Greene

Earth as Human Nurturing Fate, 1996–97
(installation view), Photo courtesy of
Don Lee

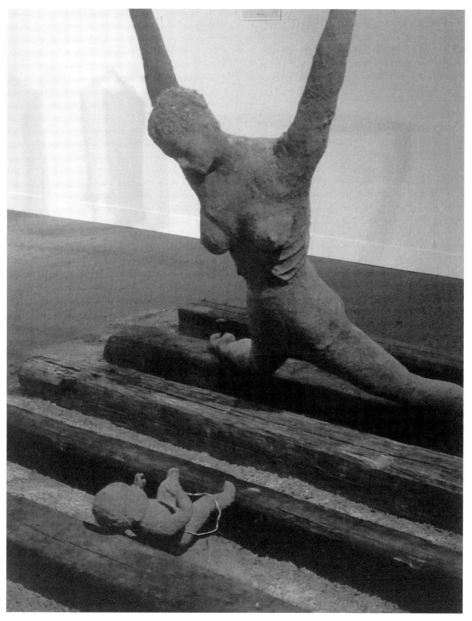

Kelly Greene, *Earth as Human Nurturing Fate,* 1996–97 (detail), Photo courtesy of Patricia Deadman

Ties that Bind...

Years ago, I found two railroad stakes behind the Woodland Cultural Centre. (My grandmother attended the residential school there.) I bought a rusted oxen bit at a second-hand furniture store when the Hudson's Bay Company celebrated its 325th anniversary of occupation in Canada; a charter granted with no recognition that this land was already inhabited. European immigrants plowed through the land anyway. I watched *Jesus of Nazareth* on TV at Easter. I woke when Jesus' hands were being nailed to the cross. I thought, "If Earth were human, in what condition would she be?" I sculpted an image of a woman—Mother Earth—crucified to the oxen bit, hands pierced by the hooks, legs spread and feet nailed to a railroad tie. Rape. The cable attached to the oxen bit represents a crane, a reference to my grandfather's ironworking. Connecting the cable to the steering wheel invokes the speed of our society, each turn of the wheel pulling the thread of existence tighter. Eight railroad ties evenly spread on the floor symbolize eight as the number of rebirth in Christian teachings. (I was raised Catholic. I find Catholicism hypocritical now and no longer practise.) Baptisteries are eight-sided. In the Bible, on the eighth day, after seven days of creation, life is renewed. I believe that life is temporary and transient. It's not over when it's over. It moves into another state. My younger brother died suddenly before I began work for this exhibit. I needed to include new life in *Earth as Human Nurturing Fate*. I placed a sculpted baby between two railroad ties, arms and legs reaching up towards its tortured mother, representing life renewal in a state of near death. *Birthing Cave* poses similar questions and concepts. The crate

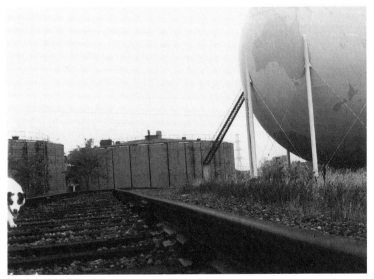

Kelly Greene, *The Breath of Earth,* 1997 (work print), Photo courtesy of the artist

became a cushy, white-fun-fur-lined coffin measuring the same as crematory coffins (my brother was cremated). One size fits all. A "birthing" hole at one end allows participants to view a photograph, *The Breath of Earth*, mounted to a seven-foot-high enclosing fence. The fence becomes not only a huge frame for the photo, but also a comment on the ridiculous condition of urban living. The fence screwed to the coffin symbolizes the passageway from one state of being to another, a visual "escape" to what's on the other side.

The photograph is taken by lying on railroad tracks that curve around a huge steel globe—a Hamilton, Ontario, landmark. Skulking to the left is my dog, Winnie. She seems to be laughing at our distress. Animals are smarter than humans.

Kelly Greene

Anne Walk

Anne Walk is a mixed-media artist who lives in London, Ontario. Her work focuses on issues of identity and its relation to the land. Walk's current installations bring together natural materials with other post-consumer by-products "harvested" from her environment. This juxtaposition allows her to expose the universality of experiences surrounding our relationship to the land.

Stand is a mixed-media piece comprising a spiral wall of burlap that hangs from the ceiling. This burlap wall opens up to allow or invite the viewer to enter. The space inside is intimate; only one or two people can enter at a time. The smell of cumin permeates the burlap bags, which were used to import the spice. Our sense of smell triggers memories: a foreign smell from a foreign land.

The spiral is a natural life form echoed in the formation of galaxies, sea shells, and DNA structure. *Stand* unfolds to reveal an interior surface on which metal nuts and power resistors have been sewn in a spiral shape. Written on the interior surface is a Sioux legend concerning the duality that exists in creation (see page 36). In this legend, a woman and a dog are in a constant, opposing action that creates a perpetual, spiraling act of creation and destruction; she continues to weave and he continues to unravel. Also written onto the surface is a series of words associated with the natural and man-made worlds in which

we live (see page 36). These words echo the spiral shape as well.

In the spiral's centre are four jute braids, hanging from the ceiling. Woven into the braids are skulls of small animals, locks and keys, feathers, and other objects that Walk has "harvested" from the land. Also incorporated is the number four, which occurs naturally in the universe: four seasons, four directions, and four phases of the moon. The four braids remind us of this inter-connectedness with nature.

The burlap spiral's exterior surface has been lightly painted with tree images. These act as camouflage or a screen. Nature itself is often witnessed through a veil or only superficially; too often our only view is from a car window or a groomed trail. What we see from the outside is not necessarily what lies within. Walk is drawing our attention to both the external and internal workings of nature, and how that relationship is a factor in establishing identity.

The artist continues her examination in the installation *Adobe Clothing: Male and Female*. In this work, Walk comments on the use of clothing as a means of identification: specific patterns and designs may indicate nationality, status, and sometimes occupation. In contemporary society, clothing with designer labels emblazoned on it provides the wearer with some form of status. This type of identification through clothing can be a perilous and superficial way of understanding who we are.

For me, this exhibit has a lot to do with coming out of the closet as an aboriginal artist. It is my first show under the label of aboriginal—my first foray into the world of minority arts groups. My feelings are mixed. I may be claiming the heritage of my family, but does that heritage claim me? Questions of community and what constitutes community continue to frustrate me. I ask others in the same boat—How "native" can I claim to be? Does it involve only blood relations?

Although I read about native issues when presented with them, I wouldn't call myself well read. In fact, the amount of stuff I don't know far surpasses what I do. I have never lived on a reserve, and although I have family on the Grand River Six Nations Reserve, I seldom see them. I was raised white. My skin is white. My hair is blonde.

When I go to the reserve, I go as a tourist. I am treated as a tourist. When I wear beads, is it appropriation? How do I stake a claim to my heritage?

Anne Walk

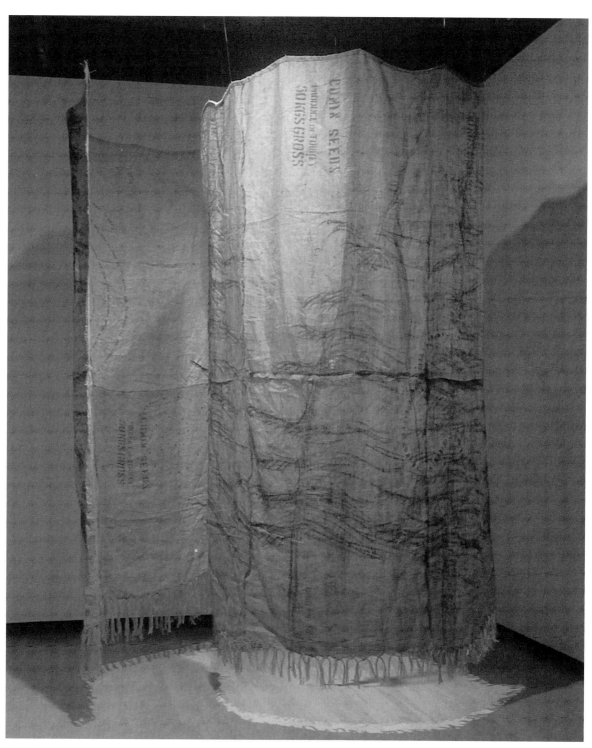

Anne Walk, *Stand,* 1997 (installation view), Photo courtesy of Don Lee

Clay-covered clothing and shoes are part of *Adobe Clothing: Male and Female.* A woman's dress and a man's suit have been dipped in clay and hung out to dry. All identifiable features, such as colour and texture, have been lost, and the outfits are reduced to a generic level. Shoes sit below each outfit, completing the image of storefront fashion.

The exterior surfaces are extremely fragile and must be re-made for each installation. This fragility parallels the frailty of our own surface identities. We wear clothing to project an image as well as to protect ourselves. We all possess different physical qualities on the "out" side, but we are all similar on the "in" side. Walk's use of clay refers to the actuality of death and how we are part of the earth: ashes to ashes, dust to dust.

By examining their relationship to the land, Mary Anne Barkhouse, Michael Belmore, Kelly Greene, and Anne Walk have created works that speak to universal concerns. The work of these four artists has crossed boundaries and cultures to forge a collective voice. Each artist has a claim, and that claim is staked within the land.

1 Mary Anne Barkhouse, Artist's statement, 1997.
2 General Philip Sheridan, 1866.
3 Mary Anne Barkhouse, Artist's statement, 1997.
4 This particular pole has had a long and interesting history, and its use is relevant to the issues addressed in the installation. Originally it belonged to Chief Tsa-wee-nok of Kingcome Inlet and was then used as a part of Edward S. Curtis's 1914 movie, *In the Land of the Head-Hunters* (Hilary Stewart, *Looking at Totem Poles*, Seattle: University of Washington Press, and Vancouver: Douglas & McIntyre, 1993, pp. 82–4.)
5 Mary Anne Barkhouse, Conversation with artist, 1997.

STAKING LAND CLAIMS

PATRICIA DEADMAN

The morning mist rises above the calm lake water. Tall white birch trees sway in the gentle breeze as pungent smells of pine fill my lungs. The melodic slaps of water echo on the massive slabs of rock. The sun colours the sky with subtle hues of orange, pink, and yellow as the rays reflect their warmth onto the moist sand. My reflection in the pools of water becomes distorted as a tossed pebble ripples the image. Is this a mirror of what is real or only an illusion of reality? Does the image reflect how others may view me? Are we able to acknowledge our individual and collective histories, families, and our intercultural relationships, so that our voices are heard above the rapids in the river? Perhaps the ability to claim one's territory within a region filled with obstacles is both a personal and an intuitive event.

A shared space, a sense of place, a moment in time are experienced as we strive for self-definition. A sense of irony, political and satirical wit, and humour, along with anger and passion, become representative of a form of survival. What connects us to the universal truth? Making connections and defining and maintaining a balance become a personal quest.

A provincial park setting affords a designated space allowing us to contemplate how we, as human beings, interact with our surroundings. In effect we become tourists in our own backyard. Whether we live in an urban or rural setting, common elements of reclaiming a sense of history—not to be confused with nostalgia— become part of a complex process of incorporating and maintaining a balance in our memories of the past. Our quality of life depends upon how we interpret what is real and what is fiction. The investigative process of self-definition involves the deconstruction of an elaborate matrix of false identities that are imposed by the social, political, and cultural milieux that transcend local com– munities. The implications of this process have reached global proportions.

Loss of tradition, language, and relationships contributes to the state of flux in which we find ourselves. Perhaps it is not so much a question of where we came from but where we are going. The winding trail presents many opportunities from which to choose—the twisting pathways interconnect.

During the early evening hours the night creatures become restless as the forest begins its descent into darkness. Heat from a campfire provides warmth—survival—as birds of prey hunt their food. With *Flock*, Michael Belmore interprets how the raven adapts to its environment in order to survive. Flying over rooftops, perched on hydro wires, and scrounging through leftover food, "the

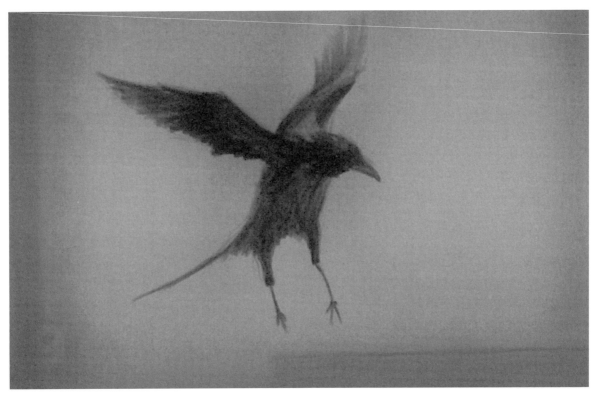

Michael Belmore, *Flock,* 1996 (detail), Photo courtesy of the artist

raven still remains true to itself."[1] This insightful analogy of self-reflection provides a realistic and authoritative voice for the urban native. How we choose to survive is shaped by our surroundings. Not everyone will find enough sustenance to ensure survival, but those of us who weather the unrelenting elements will find the means to remain true to ourselves. Just as the raven remains a raven, so the native person remains native.

If adaptation is a combination of instinct and learned behaviour, it becomes necessary to discard Western perceptions attached to native people that affect either real or imaginary projections of identification, objection, and opposition. The social and economic factors that influence society have many ramifications; it is difficult to break established lifestyles that have become acceptable and unavoidable. How are we to survive at every-day living when we are constantly struggling against dominant outside forces? Do we have the ability to stay in control, to move in and out of rationalized Western thought?

The way we learn to do even the simplest tasks, like counting, has historical references to mainstream ideology. The validity of *their* truth is scrutinized when adaptation takes any form from literature to popular culture. Hence, Belmore's reference to the poem "Ten Little Indians" through his ten ravens is a comment on how the foreign becomes viewed as acceptable. The whirlpool of

contradictions may easily and unexpectedly pull us into its depths, yet this fate may be avoided if we are aware of the consequences. Do we really exist on solid ground?

What we see reflected in our own invented tidal pools is a need to reinvent and manipulate the past so that we may claim it as our own. Hybrid narratives of tradition and personal experience are the basis of reclamation, while art that encourages only difference is a form of ethnocentrism. We may acknowledge value systems but we must also recognize their function. The anthropological and archaeological fields of Western practice actually deny modern identity or any equality and political reality. Cultural differences are systematically organized for the benefit of Western consumption while cultural appropriation, and the constructed notion of exotic aesthetics, continue to be promoted.

With such *expertise* the authoritative voice qualifies various cultures and validates their authenticity. But the discovery of deeper meaning and participation can exist only if theory and practice are intertwined. Diversity among nations exists. It is absurd to assume that all or any art form created by an individual represents a collective, since the expression is dictated by personal experience.

The collaboration of Mary Anne Barkhouse and Michael Belmore, *Reservoir*, brings together a narrative comprising the personal and collective histories of two individuals, and the fusion of technology, as a comment on the historical, economic, and social consciousness of humanity. Duplicitous meanings are apparent in claiming one's territory; symbolism, technology, and materials are connected, representing the passage of time that places the art form in its historical context. Nature and a belief system of values provide the resources to express personal and poignant statements regarding the use of natural materials, and to question the commodification of the object. Salt may be either beneficial or, when used to the extreme, harmful to man.[2] The objects—feather, bear claws, and sweet-grass braid—question what is relevant from the past, their value in terms of original intent, and the role they have in their present context. The connection between ancient and modern belief systems is apparent as the value system corresponds with the contemporary emphasis on materialism and profit.

Questions of power and control, as well as representation, are addressed in this collaborative piece. The presentation of cultural fragments represents a process of dismemberment; objects stand for cultural icons and/or a sense of the whole. An imbalance in the power relation between the observer and the observed occurs as the object stakes its claim and intervenes in the narrative that is being told. The object—as rare and exotic— also satisfies the consumer mentality, appealing to the astute collector. Being cast in salt and acrylic

resin invokes irony as the monetary value and quality are transposed. A sense of authority becomes the voice that decides which fragments are interesting and to whom. Through the new context in which the objects have been placed, the way in which they are viewed becomes paramount. Western thought must question their difference—not to the point of being noticed and acknowledged, but how they have become aestheticized and by whom.

The original context of the fragments is encapsulated by the historical function they performed for others; new roles have evolved as the environment has changed over the years. Perhaps, as established notions of the foreign become obsolete, new understandings may be established. The power of control is futile without knowledge. What is Western culture searching for? Does art provide an object as mere product for consumption? Transformation may occur when the actual reality, or function, is no longer relevant and as long as the "spirit" of the past—not the present or future—is retained. We see only what we want to see. We do not necessarily understand the whole. Where *does* one look for meaning?

As native people, we may have bought into the system of mass marketing; the truth is, however, that we must still provide for our families in order to survive.[3] Perpetuating images and tokens for profit is the responsibility of the producer. Hence, as native people, does this become a form of self-government? Who is responsible for

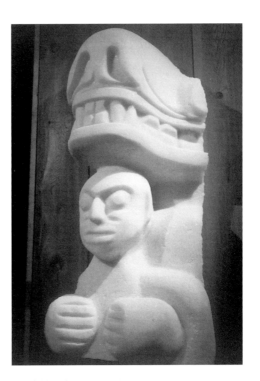

Mary Anne Barkhouse and Michael Belmore, *Reservoir,* 1997 (details), Photos courtesy of Patricia Deadman

22

A Tale of Two Quill Pigs...

As our extended family sat around the dinner table one wintery day, talk eventually meandered around to porcupines, a favoured subject of one particular uncle who has suffered much at the paws of the methodical and obsessive quill pig. Among the quill pigs' many offences were the destruction of trees through de-barking and chewing the brake lines out of cars in the wintertime whilst gnawing them for their salt content. On many occasions the pigs met an untimely end on account of their excessive quest for salt. This led to further discussion about the nature of the substance, its essential role in our diet, and also its toxic properties from over consumption.

Many years ago I had heard that a mould had been made of a house post that my great-great-grandfather had carved around the turn of the century. In 1927 the Art, Historical and Scientific Association of Vancouver had acquired a pair of house posts that Charlie James had originally carved for a chief up in Kingcome Inlet, British Columbia. They were later displayed in Stanley Park, but when one of them had deteriorated due to age and decay, a Fibreglass replica was made and the original put into storage at the Vancouver Museum. To further add to their drama, they had at one time been used as backdrop scenery in an Edward Curtis film, *In the Land of the Head-Hunters*. The original posts had gone from being functional commissioned pieces to stage props to a tourist attraction to relics in a museum vault and, lately, to installation artwork in contemporary galleries. And it probably will not end there.

In creating work whose purpose was to provoke reflection upon personal and cultural histories, we felt it was important that the iconography came from and was created by someone within our families. We wanted it to be clear that these were not items created by ourselves but from someone in our past, and that the work was reproduced in a substance that alluded to the fragile nature of understanding and the corrosive consequence of exploitation.

Mary Anne Barkhouse and Michael Belmore

23

changing attitudes and educating the masses? Will the consumer see the consequences in years to come?

These questions are addressed in the work *Cord*, as Michael Belmore captures the surreal beauty of the land in his drawings. This environment has been transformed due to clear-cutting, yet the land maintains its own presence as the wind meets the horizon. Light consumes the place: viewers feel an uneasy tension as the man-made devastation slowly penetrates their psyches.

Should multinational corporations be accountable to the public, since profits benefit them and not the community directly? Or, perhaps, should we be held responsible for land management?

As direct control over resources becomes a part of self-government, more questions arise: Who should profit? Will the federal government settle its outstanding debts and resolve land-claim issues with native people? What happens when territorial rights are claimed?

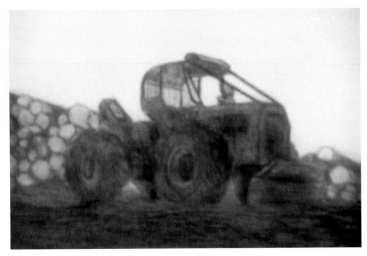

Michael Belmore, *Cord,* 1997 (details), Photos courtesy of the artist

Consumption of land resources has affected land-based economies as Western consumerist culture and capitalist structures take charge of the land without acknowledging the effects. The ecosystem provides life-sustaining elements with which man is intrinsically linked. The system is strong yet fragile; its survival depends upon a sustainable balance. However, continued despoliation, without accountability, has serious consequences for the next generation. Do our actions justify the means? Can individual and collective ideologies based solely on material gain connect with the land?

Issues of commodity, technology, and materialism are also found in the work of Kelly Greene. *Earth as Human Nurturing Fate* parallels historical accountability with the Christian belief system. The physical landscape is not a pristine wilderness on which fantasies can be imposed; rather, it is a place of harsh realities that parallel the human condition. The insistent need to contain and constrain the land by means of mapping, surveying, and preserving becomes a defense mechanism to obtain yet another form of power and control over nature. The land should not be at our disposal for forms of abuse such as clear-cutting and strip mining. Symbolizing Mother Earth as the body of a woman, Greene suggests that the abuse of the land is a kind of rape.

The position of the body is reminiscent of the crucifixion of Christ and may also be a commentary on male dominance and the abuse of women. Greene's awareness of the relationship between the woman's body and the earth recognizes the similarities—the natural ability to bleed, conceive, birth, heal, and lactate—and provides an opportunity to connect the past with the present over a period of time and space. Humanity and nature have been opposed to one another, and this opposition stresses the polarity of the relationship as well as the future consequences of humanity's actions. The land has been romanticized, colonized, industrialized. For centuries it has been depicted as a bleak, barren, and hostile wasteland. A lack of dignity and respect for the land is apparent when any connectedness to the landscape is dictated by the principles of profit. Symbolized by the use of natural and found materials, *Earth as Human Nurturing Fate* reveals a paradox of human values. Greene offers the hope that responsibility and change may be achieved by the next generation; hence the baby is detached from its mother and placed between the cracks. However, the placement of the baby is questionable—fate may be predetermined by previous actions. Either we are destined for failure or there is hope for survival in the years to follow.

The scope of cultural history comprises a rich texture of experience, cohesiveness, and layered complexities that rely on each person's ability to make conscious and caring decisions about the past and present. Individual energies and experiences influence one's actions, while connections to land and self may be explored through a wealth of human resources within a

community context. Greene draws creative energy from her personal background—native ancestry fused with Catholic religion—to present a fragmented view of societal manipulation over self, gender, race, and land.

The ability to comprehend reality, or the imagined, is elusive since it is shaped by forgetfulness of the mind, ignorance of history, and perceptions of the essence of the land. The physical and human environment is validated by a paternalistic Christian belief system of split absolutes: good versus evil, light versus dark. The supposition that earth consists of soil and dirt, hence is ungodly, and that nature is inferior to man, suggests that man must distance himself from the earth to avoid being close to the devil and evil. This world view is contrary to the matriarchal origin of the Creation story. The natural cycle of birth, growth, maturity, and decay is integrated with technology as "speed and time govern our lives, intensely gaining momentum as the millennium comes to a close."[4] Greene is optimistic that the life cycle continues.

Greene continues to comment on the relationship of man, spirit, and land with her two-part mixed-media installation, *Birthing Cave* and *The Breath of Earth*. With viewer participation, her coffin-like structure entombs sensory perception. The work addresses a ritualistic ceremony that symbolizes life, death, and rebirth, recycled back to the earth. Viewers become aware of their immediate surroundings—soft, dark, secure, or trapped—

while confined within the space with only a "birth canal" to allow light to penetrate the end of the tunnel. A personal journey initiates a sense of curiosity as desire, instinct, and place take on a deeper meaning. A metamorphic transition persuades viewers to contemplate the contents held within the boundaries of the fence, as Greene presents a critical picture of historical landmark and present consequences. The imposition of technology on the environment initiates a cataclysm, forcing participants to confront and question its intent. The ability of viewers to question their existence and sense of place within the universal scheme is, therefore, challenged.

Are advancements in science and industry beneficial to humanity, or do they supersede the natural course of life? As mere mortals, do we possess the knowledge to intersect with divine power in the quest to fulfill idealistic expectations? Greene does not present any concrete solutions to her observations. Her work, however, instills in viewers the realization that we must connect with both the inner and outer qualities of human nature, and the natural landscape, in order to survive the inevitable consequences of man's presence on earth.

Energy is continuously exchanged and transformed within the universe, creating boundaries to be crossed. The sacred or profane space becomes an ephemeral entity. Does this acknowledgement of spirit confront distortions or initiate change in our own perspective of what we

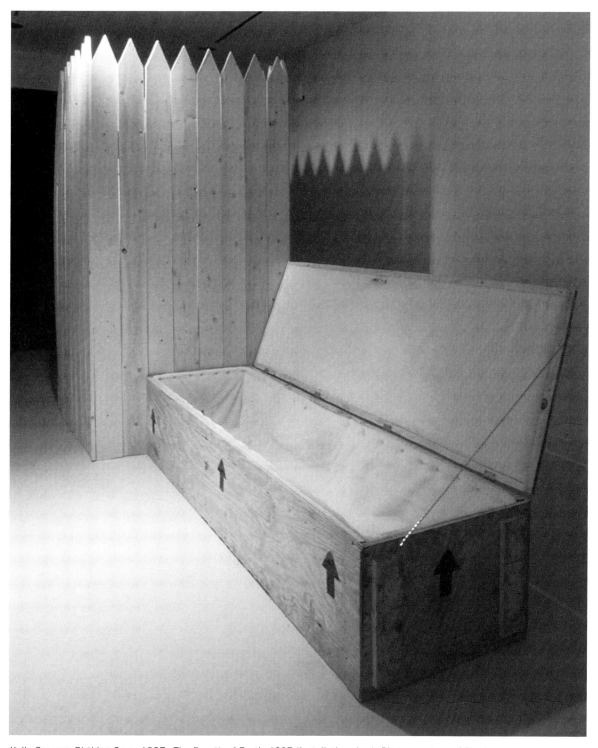

Kelly Greene; *Birthing Cave*, 1997; *The Breath of Earth*, 1997 (installation view); Photo courtesy of Don Lee

have internalized? If displacement from traditional cultural roles occurs, does spiritual experience become fragmented? What *do* we take for granted?

Man's quest for uncovering the unexplained—which may be perceived as intangible qualities internalized by the self—seems to be worthy of recognition and appreciation. Yet what is really left to be discovered? Discovery relies on first-time experience. Once spiritual boundaries have been crossed, does this acknowledgement validate unconscious thought as reality? Today's narrative landscapes are a form of reclaiming language, land, and culture—a way of life represented by spirit of place. Is art only the documentation of the human spirit?

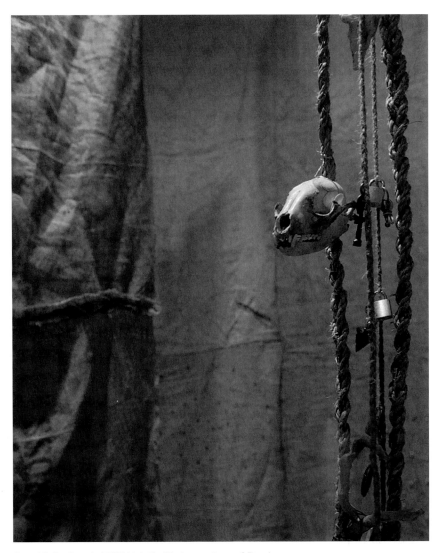

Anne Walk, *Stand,* 1997 (detail), Photo courtesy of Don Lee

Strained relationships within humanity will continue. Depending on where one stands on the shoreline, however, boundaries can be crossed if one chooses to make footprints in the sand. There is a theory that art is common property—but the creative process is not about achieving an absolute universalism. Western critical thought may define art solely according to its political action or spiritual intelligence. The merit of these characteristics reflects a paternalistic idealism that ignores and contradicts another value system: one that embraces questioning of, and searches for, spiritual depth and social meaning. The artwork created by the "other" becomes disempowered through this Western political manoeuvre, which also subjects individuals to degradation. Do we not have the ability to access human qualities and emotions that are transcultural and indicative of the human spirit?

Self-expression takes many forms—painting, sculpture, storytelling, music, dance—yet the ability to trust one's instincts has been influenced by modern and postmodern interpretations. Once again, the truth has been altered by the perceptions of the dominant society. Do we say what we really mean or have our perceptions been dulled to sterile predictability? *Who* are the art experts anyway?

Anne Walk questions history as absolute truth in *Stand*, a commentary on what we choose to recognize as reality versus that which we imagine. "Anthropologist Marshall Sahlins wrote that humans never interact directly through a system of symbols. While I don't believe his statement to be absolutely true, I believe that through symbolic means, we create a dialogue with our surroundings."[5] How do we interpret our real world? Natural materials possess inherent qualities, but are often appropriated from nature without the benefit of creative expression. The characteristics of materials must be learned and respected in order to achieve an integration of object and creative thought. Walk successfully integrates natural materials into her work. Her use of the spiral as a universal and non-culturally specific symbol, or icon, combines references to pre-contact trade routes with objects found within our own "natural" surroundings.

We are able to make personal connections with the land while we are consumers of modern conveniences—computers, microwaves, and in some cases, running water—all for the sake of better living conditions. Necessity versus luxury. Past versus present. The hand-knotted fringes are reminiscent of blankets, reminding us of the traditional, functional purpose of this cultural object, but also of the epidemic of smallpox, which was passed along by the infected cloth. Memory and recollection are emotional reactions triggered by the subtle passage of time and space. Walk creates an environment where our sensory perceptions are consumed by the odour of cumin and the texture of burlap.

The objects intersect our personal space; their presence signifies a journey through time and space as the importance of movement is monumentalized by personal experience. A state

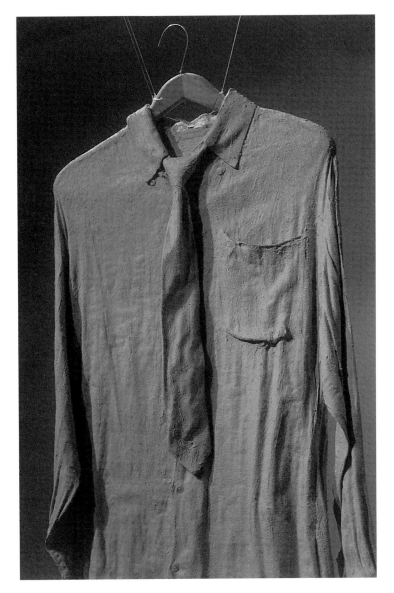

Anne Walk, *Adobe Clothing: Male and Female,* 1997 (detail), Photo courtesy of Patricia Deadman

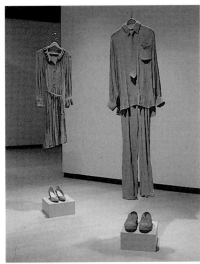

Adobe Clothing: Male and Female, 1997 (installation view), Photo courtesy of Don Lee

of disorientation is possible as we search for authentic reality and desire for truth. Gratification from this experience results in our ability to interpret history, cultural references, and personal knowledge.

Anne Walk questions cultural identity in *Adobe Clothing: Male and Female*, a set of generic clothing that is symbolic of decoration versus function-alism. As objects, the clothes represent function by being a form of protection. They are sturdy and enduring, yet are also characteristic of what is precious and fragile. As individuals, our lives differ due to various circumstances, yet we share the same space and are connected in similar ways. Seeking purity and defining origin serves what purpose? To be categorized once again by the dominant? Do we not do this to ourselves as well? What do we consciously claim as our own?

In genetics, DNA combines with learned behaviour to define personality. What is inherent cannot be denied, but to either acknowledge or ignore cultural tradition and identity is a personal choice. Society dictates how we identify ourselves in any given situation. As native people from different backgrounds, families, and environments, the need to classify in order to satisfy Western ideology seems an exercise in futility—non-native families do not face the same scrutiny of identification.

Interaction among our own families may become strained as prejudice and lack of tolerance become the norm. Narcissism has become acceptable behaviour in today's social context as we become independent of our communities. Walk questions our identity as assimilation, adaptation, and stereotypical images are both dispelled and reinforced. Clothing—from the land and about the land—initiates a discussion of how we as individuals are affected by our history and collective mind. Notions of cultural purity, like ethnic and gender identity, can imply definite positions and suggest that we be constrained within an abstraction of an imagined culture.

The basis for categorization is dependent on the hierarchical order of class, race, and gender. Authentication of identity is a form of power and desire—internal racism has also become a reality for many—as the dominant society continues to conquer and divide. As individuals, however, we are in control of the self. This is evident when we realize how the native perspective is often misinterpreted and misplaced from the context of its deserving place. Hence, *Adobe Clothing: Male and Female* symbolizes present circumstances of the individual dictated by time and place. Will the wind carry our voices beyond the forest trees?

Appearances are not always what they seem. True identity is not dependent upon governmental definition. The individual adapts to his or her natural surroundings. A state of perpetual displacement occurs only if people believe that they are supposed to be somewhere else within their environment, as defined by the dominant view. A continued deconstruction of values,

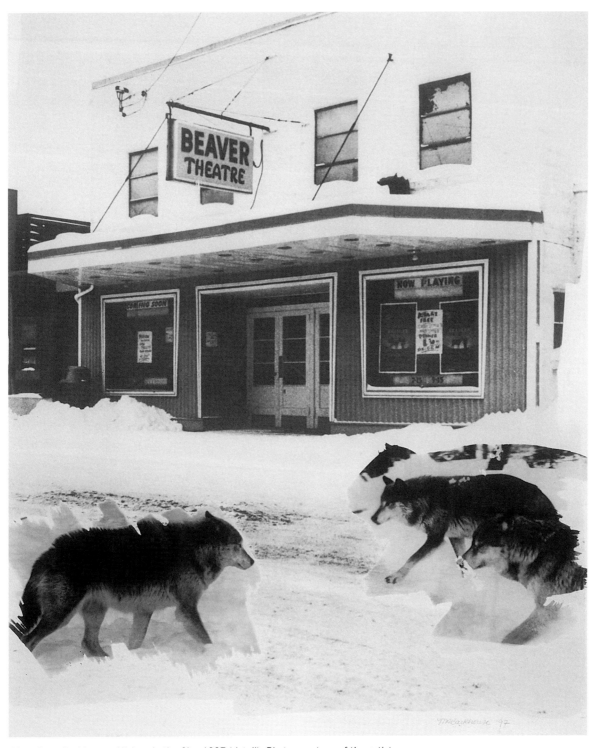

Mary Anne Barkhouse, *Wolves in the City,* 1997 (detail), Photo courtesy of the artist

traditions, and images contributes to a society that is always in transition between here and there. Reality is therefore best depicted as a set of circumstances that allows territory to change throughout time. Are we no longer able to judge what is a true representation of ourselves? Are we psychologically colonized to what we are supposed to be?

As the rocks along the shoreline are exposed to the sun by the changing tides, appearances expose the "other" side of human nature. *Wolves in the City*, a suite of five images by Mary Anne Barkhouse, provides an insightful perspective—combined with a biting sense of humour—into the existing relationship between native and non-native people. Barkhouse presents work that investigates the notion of otherness.

Physical displacement from a given place within the natural environment occurs as mankind pursues his interest in procuring a desirable habitat for himself. The unsavoury components are present and integrated within the environment as technological and social development progresses. Every day, one's lifestyle is affected as the "other" is present to realize "its" rightful place in society. Barkhouse presents the wolf as the undesirable—the other. Is society so judgmental of the other to make it a scapegoat for all actions? Is the fear of "them" the same fear that we dread in ourselves?

As survival depends upon cohabitation, a mutual understanding of a collective commonalty

may be fostered. Is social behaviour a process of paranoia and a form of narcissism? What is normal? Whose value system is being scrutinized? Connections to heritage, community, and the land are addressed as these elements are considered as a whole. The national debate over defining Canadian identity provides the opportunity to explore a diverse sense of place within a geographic space.

Location, territory, and possession are evident in *Wolves in the City*: the Beaver Theatre in Minden, Ontario; the Indian Head in Indian Head, Saskatchewan; the Parliament Buildings in Ottawa, Ontario; the Neechee Friendship Centre in Kenora, Ontario; and Night Danger Crossing in Northern Ontario are representative of what is familiar territory. Laden with historical significance, these "found" places are recognizable, and personal connections to their symbolic references are universal knowledge. As the wolves descend into this domain of their "other," survival becomes an instinctive and territorial right—a fundamental process that is unique to the individual. Unwanted elements enter our personal space and are unavoidable, but how do we define a value system from which we can react?

From coast to coast, individuals must reflect on the self in order to understand their neighbours. Similarities and differences are acknowledged, tolerated, and even ignored. Yet as we continue to share the landscape, continual movement within the grass provides opportunities to discover new allies. The fundamental process of survival is dependent on

the individual. What we give back to the community becomes the ultimate recycling program.

Claiming or staking one's territory is an individual process rooted in a mixture of historical references, memories, and experiences and fused with technology, time, and space. Tourism sates the curiosity but, from a world-view perspective, provides only a fragment of the whole. We become selective and choose what we want to see. Do we have the courage to see what is not printed in the glossy brochures? From a First Nations perspective, Staking LAND Claims provides a point of departure for individuals to question their place and connection to the land. Ochre streams, magenta mountains, viridian rocks, and crimson lakes—our view of the land may not necessarily match an idyllic perception. No boundaries, no barriers, no property owned. Is there such a place over the horizon?

1 Michael Belmore, Artist's talk, 1997.

2 Mary Anne Barkhouse and Michael Belmore, Artists' talk, *Reservoir*, 1997.

3 Michael Belmore, Artist's talk, 1997.

4 Kelly Greene, Artist's talk, *Earth as Human Nurturing Fate*, 1996–97.

5 Anne Walk, Artist's statement, 1997.

GUIDELINES FOR BIRTHING CAVE

KELLY GREENE

These guidelines were created by Kelly Greene to maximize the viewer's experience with the installation work *Birthing Cave*. The guidelines were displayed to the viewers in a book format placed at the entrance to the room. The physical nature of the participants' actions and experiences emphasizes the issues addressed in Greene's work.

In order to view the photograph *The Breath of Earth*, which is mounted within the fence structure, the viewer must follow the guidelines. Upon completing the instructions, participants sign the guest book with a feather-and-leather pen, recalling the tradition of signing the guest book at a funeral.

Guidelines

1. Take off shoes before entering coffin (make sure socks or feet are clean and dry).

2. One person at a time.

3. Lie on side with head toward fence.

4. Pull down lid, closing fully.

5. Lie flat on stomach; peer through birth opening to view image.

6. Relax.

7. Two-minute time limit.

8. No pushing or shoving while waiting in line.

TEXT FOR STAND

ANNE WALK

Anne Walk provides viewers with two bodies of text addressing the relationship of culture and the environment. The first is a Sioux legend; the second is a series of words associated with natural and man-made landscapes. The installation *Stand* incorporates the universal symbol of the spiral throughout the work. Viewers start their journey from the outside of the burlap spiral, and as they progress towards the centre, they are confronted with various found objects as well as the two pieces of text.

For thousands of years an old Indian woman has been sitting in the moonlight, decorating a large bag with porcupine quills. Near her a fire is burning bright and a kettle of herbs is boiling. Nearby sits a small black dog watching her. When the old Indian woman puts down her work to stir the herbs in the kettle or add more wood to the fire, the little dog quickly unravels her quillwork. As fast as she sews and decorates, the dog unravels it. If the old Indian woman ever completes her work, the world will come to an instant end, because she will put the world in her bag and carry it off.

Earth, water, mud, clay, stone, bone, skin, hair, plant, wood, paper, fire, village, mineral, ore, metal, glass, material, chemical, wire, electric, light, engine, industrial, mechanical, urban, synthetic, improve, artificial, bigger, better, atomic, nuclear, commuter, computer, micro, memory, information, commercialization, investment, bottom line, power, ozone depletion, global, recycling, old growth, activism, human rights, greenpeace, protest, organic, conserve, restore, fight, cleanse, feed, help, earth.

THE EXHIBITION

LIST OF WORKS

Installations are site-specific and dimensions are variable. All works courtesy of the artists.

MARY ANNE BARKHOUSE

Wolves in the City 1997
Suite of five Cyanotype and Vandyke prints on paper mounted on blue wall
76 cm x 112 cm each

MICHAEL BELMORE

Flock 1996
Ten graphite on lexan
6 cm x 10 cm x 15 cm each

Cord 1997
Graphite on lexan in light box with two graphite on lexan mounted on adjacent wall
15 cm x 12 cm x 61 cm and 6 cm x 15 cm x 20 cm respectively

MARY ANNE BARKHOUSE AND MICHAEL BELMORE

Reservoir 1997
Mixed-media installation consisting of cedar, and copper and metal stands, salt, resin

KELLY GREENE

Earth as Human Nurturing Fate 1996–97
Mixed-media installation consisting of eight railroad ties, two railroad spikes, road sand, hemp, oxen yoke, steel cable, steering wheel

Birthing Cave 1997
Mixed-media installation consisting of wooden crate, fun-fur fabric
213 cm x 61 cm x 46 cm

The Breath of Earth 1997
Mixed-media installation consisting of black and white silver print, ashes, road sand, wooden fence
121 cm x 121 cm x 213 cm

ANNE WALK

Stand 1997
Mixed-media installation consisting of burlap cumin-seed sacks, found objects
213 cm x 731 cm in spiral configuration

Adobe Clothing: Male and Female 1997
Mixed-media installation consisting of clay, porcupine quills, coat hangers, clothing, shoes

ITINERARY

Walter Phillips Gallery, Banff, Alberta:
14 February–31 March 1997

Thunder Bay Art Gallery, Thunder Bay, Ontario:
16 September–9 November 1997

Woodland Cultural Centre, Brantford, Ontario:
9 February–20 March 1998

FUNDING

Canada Council for the Arts, Ontario Arts Council, Toronto Arts Council

PRODUCTION STAFF

Walter Phillips Gallery: Catherine Crowston, Heather Klassen, Mimmo Maiolo, Jane Paterson, Debra Reeve, Christopher Eamon, and MJ Thompson

Aboriginal Arts Program: Marrie Mumford, Rebecca Ward, Heather Henry, and Debra Prince

Media and Visual Arts: Ed Bamiling, Ernie Kroeger, Don Lee, Tara Neish, Steve Nixon, Anisa Skuse, and Randy Tinsley

ACKNOWLEDGEMENTS

MARY ANNE BARKHOUSE AND MICHAEL BELMORE

Mary Anne Barkhouse and Michael Belmore would like to gratefully acknowledge the Toronto Arts Council, the Canada Council for the Arts, the Ontario Arts Council, Mr. and Mrs. Alan Barkhouse, and Frank Shebagaget.

KELLY GREENE

Wyn Geleynse and Madeline Lennon of the University of Western Ontario's Visual Arts Department. The Canada Council for the Arts. The staff at the Walter Phillips Gallery, the Thunder Bay Art Gallery, and the Woodland Cultural Centre for making my first touring group exhibit such a memorable one.

All visitors to the exhibit, but particular thanks to all those who entered into the coffin. My son, Julien, for keeping me grounded. My partner, Rich, for keeping me sane.

ANNE WALK

Anne Walk would like to thank the Woodland Cultural Centre and the Ontario Arts Council.

PATRICIA DEADMAN

I am extremely grateful to Mary Anne Barkhouse, Michael Belmore, Kelly Greene, and Anne Walk. It has been a pleasure and an honour to have had the opportunity to work with dedicated artists who give support and who possess integrity and a wicked sense of humour. Marrie Mumford, Director; Catherine Crowston, Curator; Carol Phillips, Director; Janet Clark, Curator; and Tom Hill, Curator, for your continued support and assistance. My thanks to the gallery staff, support staff, and installation crew of the Walter Phillips Gallery, Aboriginal Arts Program, The Banff Centre for the Arts, Thunder Bay Art Gallery, and the Woodland Cultural Centre. Thank you, Lynn Hill, for your insightful writing. Thank you, Lori Burwash, Lauri Seidlitz, Paul Seesequasis, Jon Tupper, Don Stein, and Ann Hibberd for your contributions to the publication. My appreciation to Heather Henry and MJ Thompson, an unforgettable road trip. My thanks are extended to the many community members at the En'owkin Centre, Penticton, British Columbia; Red Crow Community College, Stand Off, Alberta; Nakota College, Morley, Alberta; and the Plains Indian Cultural Survival School, Calgary, Alberta. Special thanks to Morgan Wood and Jean Deadman.

BIOGRAPHIES

MARY ANNE BARKHOUSE was born in Vancouver, British Columbia, in 1961 and currently lives in Minden, Ontario. She is a member of the Nimpkish Band at Alert Bay on Vancouver Island. She received an Honours Degree in the New Media Program from the Ontario College of Art in 1991. Her work has been exhibited in *Multiplicity: A New Cultural Strategy* (1993), University of British Columbia Museum of Anthropology, Vancouver; *First Nations Art* (1990–95), Woodland Cultural Centre, Brantford; *AlterNative: Contemporary Photo Compositions* (1996), McMichael Canadian Art Collection, Kleinburg; the Canadian Museum of Contemporary Photography, Ottawa; and recently with the *Lick* Artists' Collective, Toronto (1997). Barkhouse's work is in the collections of the Indian Art Centre, Ottawa; UBC Museum of Anthropology, Vancouver; Thunder Bay Art Gallery; the Walter Phillips Gallery at The Banff Centre for the Arts, and numerous private collections.

MICHAEL BELMORE was born in Thunder Bay, Ontario, in 1971 and currently lives in Minden, Ontario. Belmore is of Ojibway heritage. He graduated from the Ontario College of Art in 1994 with an A.O.C.A. in Sculpture/Installation. Michael's installations incorporate acrylic, metal, wood, photography, and text. He has exhibited his work at Garnet Press Gallery, Toronto, in a solo, site-specific installation, *Reformation* (1996). Belmore's work has been included in numerous group exhibitions since 1988: the *Lick* Artists' Collective, Toronto (1997); *Naked State: A Selected View of Toronto Art* (1994), The Power Plant, Toronto; *Native Love* (1995–96), Montreal, touring to Artspace, Peterborough, and AKA, Saskatoon. He has also exhibited at Gallery 76, Toronto (1994), and the Workscene Gallery, Toronto (1993). Belmore's work is in the collections of the Indian Art Centre, Ottawa; McMichael Canadian Art Collection, Kleinburg; Thunder Bay Art Gallery, and numerous private collections.

KELLY GREENE was born in Buffalo, New York, in 1962. She lived in Albuquerque, New Mexico, for twenty years and moved to London, Ontario, in 1989, where she currently lives. She is of Mohawk/Italian heritage from the Six Nations Reserve. Greene completed her Bachelor of Fine Arts at the University of Western Ontario in 1994. Her solo exhibitions have included *A Patio Party by the Cottage Near the Woods,* Palace at 4 A.M., London (1996), and *Iroquois Solar Longhouse, 1994 Version,* Museum of Archaeology, London (1994). Selected group shows include *First Nations Art,* Woodland Cultural Centre, Brantford (1990–98); *Godi'nigoha': The Women's Mind,* Woodland Cultural Centre, Brantford (1997); *Be It So It Remains in Our Minds,* a collaborative installation for the Oh Canada Project, Art Gallery of Ontario (1996); *Festive Banquet* (1994) and *Festival of Lights* (1993), York Quay Gallery, Harbourfront Centre, Toronto; and *Remembrance* (1995) and *A Cup for a Cup* (1993), Forest City Gallery, London. Greene has also exhibited at the McIntosh Gallery, London (1994); Native

Indian/Inuit Photographer's Association, Hamilton (1992); and London Regional Art and Historical Museums, London (1990, 1991). Her work is in the collection of the Woodland Cultural Centre and in private collections.

ANNE WALK was born in Brantford, Ontario, in 1964 and currently lives in London, Ontario. Walk is of Cayuga/Hungarian heritage from the Six Nations Reserve. She is presently attending the University of Western Ontario to complete her Bachelor of Fine Arts in visual arts. Anne has previously worked with clay to create sculptures and mixed-media installations. She travelled throughout Southwestern Ontario to locate, purify, and build with natural clay, culminating in using a traditional pit fire. Walk's work has been exhibited at *First Nations Art,* Woodland Cultural Centre, Brantford (1997); Forest City Gallery, London (1997); Ingersoll Creative Arts Centre, Ingersoll (1996); and Woodstock Art Gallery, Woodstock (1992). Her work is also included in private collections.

PATRICIA DEADMAN was born in Ohsweken, Ontario, and currently resides in London, Ontario. She is Tuscarora and was raised in Woodstock, Ontario. Deadman received her Fine Art Diploma from Fanshawe College, London, in 1986 and completed her Bachelor of Fine Arts at the University of Windsor in 1988. She participated in the photography residency at The Banff Centre for the Arts in 1991 and has exhibited throughout Canada and the United States since 1986. Deadman's solo exhibitions have included *Fringe Momentum,* Thunder Bay Art Gallery (1990); *A Little Bit of Dance,* Philadelphia (1992); and *This Land Reserved,* Woodstock (1995). Her recent group shows

include *Young Contemporaries,* London (travelling 1996–98); *Strong Hearts: Native American Visions and Voices,* Washington (travelling 1996–98); and *Godi'nigoha': The Women's Mind,* Woodland Cultural Centre, Brantford (1997). Her work is in numerous collections including the Walter Phillips Gallery at The Banff Centre for the Arts; Vancouver Art Gallery; Thunder Bay Art Gallery; Royal Ontario Museum, Toronto; and the Indian Art Centre, Ottawa. Previous curatorial/teaching projects have included *Inside/Out,* Center for Exploratory and Perceptual Art and Neto Hatnakwe Onkwehowe, Buffalo (1996), and *Women's Spirit: Keepers of the Earth,* Thunder Bay Art Gallery and Beendigen Inc., Thunder Bay (1997). In 1997 to 1998, Deadman was curatorial intern at The Power Plant Contemporary Art Gallery in Toronto.

LYNN HILL was born in Hamilton, Ontario, and is a member of the Iroquois Confederacy, Cayuga Nation from Six Nations Reserve. She has a Bachelor of Arts in Art History from the University of Victoria. Hill's curatorial practice includes *Lick,* Toronto (1997); *RePresenting,* McMichael Canadian Art Collection, Kleinburg (1997); *Godi'nigoha': The Women's Mind,* Woodland Cultural Centre, Brantford (1997); *AlterNative: Contemporary Photo Compositions,* McMichael Canadian Art Collection, Kleinburg (1995) and Canadian Museum of Contemporary Photography, Ottawa (1996); and *Jane Ash Poitras, Recycled Blackboards: Rethinking Lessons in History,* Royal Ontario Museum, Toronto (1992). From 1993 to 1998, Hill was Assistant Curator—First Nations Art at the McMichael Canadian Art Collection in Kleinburg. She now lives in Vancouver, where she is the Curator in Residence at the Museum of Anthropology at UBC.

INDEX